Girl
Next Door

Also by Beth Peters
Published by Ballantine Books:

TRUE BRIT: *The Story of Singing Sensation*
 Britney Spears

Books published by The Ballantine Publishing Group
are available at quantity discounts on bulk purchases
for premium, educational, fund-raising, and special
sales use. For details, please call 1-800-733-3000.

Girl Next Door

All About Katie Holmes

Beth Peters

BALLANTINE BOOKS • NEW YORK

A Ballantine Book
Published by The Ballantine Publishing Group
Copyright ©1999 by Beth Peters

All rights reserved under International and PanAmerican Copyright Conventions. Published in the United States by The Ballantine Publishing Group, a division of Random House, Inc., New York, and simultaneously in Canada by Random House of Canada Limited, Toronto.

Ballantine and colophon are registered trademarks of Random House, Inc.

www.randomhouse.com/BB/

Library of Congress Catalog Card Number: 99-91908

ISBN 0-345-43828-0

This is an independent biographical work and is not authorized by Katie Holmes.

Manufactured in the United States of America

First Ballantine Books Edition: March 2000

10 9 8 7 6 5 4 3 2 1

To my little sis, Debbie

Author's Note

When I was in high school, all I wanted was for the captain of the debate team to notice me. I tried everything: acted like I could not care less (strike one); baked him cookies (strike two); threw myself at him in biology class (strike three—I almost set the place on fire by accidentally knocking over a Bunsen burner).

Finally, I simply decided to stop stressing and to be myself. *Voila!* Mr. Dreamboat actually took an interest (which is exactly when I lost interest). The lesson to be learned: Be true to who you are.

AUTHOR'S NOTE

Now that I'm a few years older, I've realized this: So what if I adore microwaved bananas, despise chocolate, and know every Barry Manilow song by heart? Big deal if I love to box and I think ballet is a bore! My husband doesn't seem to mind one bit (or if he does, he loves me too much to tell me).

What I admire most about Katie Holmes is the fact that she's *always* comfortable in her own skin. How did someone so young manage to get so self-assured and successful? A good upbringing certainly had a lot to do with it (thanks, Mom and Dad!), but I think a lot of it comes from Katie herself. She lets no one tell her what to do or how to think—much like Joey Potter, the character she plays on television's *Dawson's Creek*. You won't catch her succumbing to any trend du jour or partying with the wild crowd. Why? Because Katie doesn't have to do anything to impress people. They're already impressed by her awesome talent and her natural radiance.

I certainly was, from the first time I spied her at an event hosted by the WB network. The network was unveiling *Dawson's Creek*,

AUTHOR'S NOTE

what it hoped would be its biggest hit yet. It is, and so is Katie. And even though I only had the chance to talk to Katie for a moment at that event, it was easy for me to see that *this* is a girl who's bright, talented, and—we can't leave out—beautiful.

If she's come this far, this fast, just think of what the future could hold. . . .

Contents

Girl Next Door

Do Nice Girls Finish First?

*Y*ou better believe it—Katie Holmes is living proof! You just can't ignore this girl next door. Why? Because she's *everywhere*: magazine covers, movie premieres, talk shows, charity events—not to mention the hottest teen drama on TV every Wednesday (as of this writing) night. All that attention and adulation might go to another girl's head, but not Katie's.

"She's really normal, you know?" says her *Dawson's Creek* compadre, Michelle Williams. "I mean, she's got it all under control."

KATIE HOLMES

Maybe that's why *Creek* creator Kevin Williamson saw her as the perfect pal Joey: smart, sassy, and (you better believe it) oh-so-sexy. Girls want to be her best bud; guys want to be her boy toy.

"She has that quality," Kevin told *YM* magazine. "That unique combination of talent, beauty, and skill that makes Hollywood come calling. To meet her is to fall under her spell."

"There's so much more to Katie than meets the eye," confessed co-*Creek*er James Van Der Beek during the show's early promotional interviews. He was hinting of course at the hots his character would develop for her character (and we avid viewers all know that didn't take long!), but also at the depth of his costar's talent and the complexity of her personality.

Katie, like Joey, is loyal to her friends and family. She's all about simplicity, wearing easygoing clothes and often no makeup—unless she's heading to a glamorous event or party—and harbors a no fuss/no muss philosophy in her style. She hates her hair ("too straight"); wishes she were shorter ("I feel like a beanstalk");

pokes fun at herself ("I'm such a nerd!"); and sees herself as more "Plain Jane" than drop-dead gorgeous. She giggles (a lot), she blushes (even more), and among the cast and crew of *Dawson's Creek* she's the constant butt of practical jokes.

"I admit it," she told *Seventeen* magazine. "Sometimes things just go right over my head. I guess growing up in Toledo, Ohio, and going to an all-girl Catholic school, I'm a little more sheltered."

But nobody would ever accuse Katie of being naive when it comes to her career. She's played it very smart, constantly challenging audiences as well as herself with varied parts that could best be described as the anti-Joey. "I don't really want to get stuck being a type," she said while promoting her role as a social outcast in the feature film *Disturbing Behavior*. "You have to try new things or you don't grow as an actor or a person."

And she has grown up, right before our eyes, evolving from a gawky teen tomboy to the poised and polished twenty-one-year-old she is today. The media has dubbed her one of the hottest young stars

in showbiz (not to mention one of the most beautiful), but she's kept her feet firmly planted on the ground.

"I still have the same friends; I still go home and hang out at the same places and do the things I've always done," she told cable's *E!* network. "I don't think any of those things will ever change because they're what's most important to me. Besides, if I ever got carried away, my family would probably be like, 'Hey, who do you think you are?' "

Katie *is* real—which is precisely her appeal. Critics and colleagues alike shower her with praise (the phrase "a natural" comes up often). Meeting her in person for the first time, she seems more like a kid who could be in your homeroom class than a Hollywood screen queen. Dressed down in faded jeans, a tee shirt, and a baseball cap, she greets you not with a handshake, but a warm hug and a big "Hiya! I'm Katie." As if you don't know!

It's totally believable that one day she could ring your doorbell (or better yet, climb in through your window) and introduce herself as your next-door neighbor.

GIRL NEXT DOOR

And if that happened (don't ya wish?), there'd be no doubt you'd wind up friends for life.

Because Katie Holmes is a keeper.

Crazy 'Bout Katie?

- Write to her c/o *Dawson's Creek*, c/o The Warner Brothers Television Network, 4000 Warner Boulevard, Burbank, CA 91522
- Check out these unofficial (but seriously authoritative) Web sites:
 www.katie-holmes.com
 www.netw.com/~aro/katie.htm
 www.geocities.com/Hollywood/Studio/8617/katieh.html
 http://members.xoom.com/MagSea3103/katie_holmes.html

Holmes' Sweet Home

"At Thanksgiving, the whole family comes to our house. After dinner, we all go bowling. That's the kind of life I come from."

—KATIE HOLMES

*O*kay, it's not exactly *Beverly Hills, 90210*, but a few famous faces have hailed from Toledo, Ohio, 43623—*M*A*S*H*'s Jamie Farr, women's rights activist Gloria Steinem, and comedian Danny Thomas (who even has a park there that's named after him now). Then came Katie Holmes, a pigtailed, apple-cheeked little girl who suddenly became (virtually overnight) the biggest thing to happen to Toledo in the last century.

The Toledo Chamber of Commerce calls her "an all-american young lady" and says

she's a source of pride to her hometown. Friends who grew up with her just roll their eyes and laugh: To them, she's just Katie.

Kate Noelle Holmes was the youngest in a family of five children (she has three older sisters and one older brother). "I was always tagging along," she told *Rolling Stone* magazine. "I loved being the baby." Her mother Kathy is a stay-at-home mom ("tall, beautiful, and very ingratiating"), her dad Marty a respected local lawyer ("he's aggressive, but underneath it he's a teddy bear"). Growing up, her home was loving but strict (she had a 12:30 A.M. curfew—no exceptions—on weekends) and, admits Katie, her older siblings were just as overprotective: "I don't have four siblings, I have six parents," she told *Life* magazine. She recalls being grounded a few times, "But if my parents even yelled at me, it would tear me apart."

Her bedroom was filled with Barbie dolls (not to mention the Dream House, hot dog stand, and workout center), and teddy bears. Katie also had a lot of idols

of her own. She wallpapered her room with pictures that she clipped from several teen 'zines of Leonardo DiCaprio and Dean Cain. "I had a very happy, very normal life," she told *Rolling Stone*. "Maybe I was a little sheltered, but I feel very sad when I see kids who have experienced too much too young. I'm glad I could wait this long before I had to deal with reality."

She met her best friend, Meghann Birie, back in kindergarten. "We've always been like sisters," Meghann told *YM*. "Ever since I spotted her in these overalls."

The pair went to school together, the all-girl parochial Notre Dame Academy. Forget Capeside High—this was the kind of place where they measured your uniform skirt hem to make sure it wasn't too short! "Every day, we'd kneel on the floor and have it no more than two inches above our knees," Katie told *TV Guide*. "I didn't have it super-short, but if you had it too long, you were such a dork. You looked like a freshman."

The school was taught by strict nuns, and sex—the topic du jour on *Dawson's Creek*—was reduced to a one-day phys ed

class. "They showed transparencies and we took notes," Katie recalled. "And I was like, 'I don't get it.' "

Katie and her classmates took their education seriously. "It was the kind of place where students cried about getting a 92 instead of a 93," Katie once confessed. So of course she was a straight-A student, one whom the sisters describe as "very focused, bright eyed, eager, and happy." Since there were no boys attending her school, she once commented, "Our self-image was not based on how boys perceived us. Everything was about academics, but in hindsight, I think we missed out socially."

Katie was "always in chorus," and one thing she remembers is that she even dressed like a boy to play a dancing waiter in a school production of *Hello, Dolly!* But she also has said, "I never thought I'd be an actress. I was from Ohio. I was, like, 'Get a grip!' "

She also didn't hail from a showbiz family. "I'm, like, a freak or something," she joked with Jay Leno. "They're all so

athletic and I was always horrible at sports."

Recognizing that her daughter needed a little "work on her graces," Katie's mom enrolled her in the nearby Margaret O'Brien Modeling School in her early teens. Her mother decided it would be good for her—not to launch her into a modeling career or anything, but to teach her daughter proper manners and poise.

Students from the school went to the International Modeling and Talent Association "Hooray for Hollywood!" annual convention in New York to meet and greet agents. Katie was just fourteen when she went to her first conference. But while she was overwhelmed, the agents attending weren't. Luckily, what a difference a few years makes: She returned at age seventeen with a prepared monologue from *To Kill a Mockingbird* and won the talent competition. No less than thirty agents were wowed and one—Al Onorato—tried to woo her to LA for a round of auditions and a pilot season.

But Katie's dad wasn't too thrilled by the prospect. In fact, he always assumed

his darling daughter would have a career in medicine. The trip would take Katie away from Toledo for six weeks, and he certainly didn't want her sacrificing her education.

"We had everybody in Toledo trying to convince him to let me go," Katie recalled. Luckily—with lots of begging and pleading (and assurances she'd be back in time for the start of her senior year)—her dad finally acquiesced, and off Katie headed to Hollywood with Mom (armed with her knitting) as chaperone.

"It was hard," recalled Katie's best friend Meghann, "because we'd never been apart for that long." But Katie assured her pal she'd be back before she knew it, and that everything would be back to normal.

Little did she know that her life was about to change—forever. . . .

A Holmes History

Date of birth: December 18, 1978
Height: 5'8"
Weight: 108 pounds
Eyes: Hazel
Hair: Brown
Clothing size: A perfect size 4

High School, Holmes Style

The place: The Notre Dame Academy, 3535 West Sylvania Avenue, Toledo, Ohio 43623.
Principal: Sister Mary Carol Gregory
Number of students: 740 (all girls)
Homerooms: 34
Grades: 9–12
Type of school: Catholic
Mascot: Eagle
School colors: Royal blue and gold

Hollywood, Here She Comes

"It all happened so fast."
—KATIE HOLMES

\mathcal{T}he best career advice Katie Holmes ever received came from her dad: "Do your best, and if they don't like it, s—— on them."

A bit bold? You betcha. But you know it's a philosophy the tough-as-nails Joey would embrace: Show 'em what you got, and if they don't choose you, hey, it's their big loss.

Katie kept this bit of advice in mind when she headed off to Hollywood. With virtually no acting experience behind her, she thought she really didn't stand a chance.

Still, she reasoned, if she didn't seize this opportunity, she might always wonder, "What if?" So she took a deep breath and boarded the plane to LA—with her mom along as chaperone and cheerleader.

"The first thing every casting director says is, 'How big are you?'" she told *Us* magazine. (For the record, she stands 5'8" in socks.) But of course, not even her height ("way taller than your average girl! It's taken me forever to embrace it!") stood in her way. Unbelievably, Katie aced her very first audition. Director Ang Lee and coproducer/screenwriter James Schamus took just one look at her ("I said, 'This is it, this is a movie star,'" Schamus recalls) and realized she'd be the perfect person to play Tobey Maguire's snooty upperclass girlfriend in the movie *The Ice Storm*.

Her parents, after reading the racy script set in the 1970s, were a bit nervous (her mom even burst into tears). *The Ice Storm* features rampant wife-swapping and pot smoking, and even a scene where Katie was required to pass out from drinking and drugs. "I convinced them," she told *Us*, "that this was a movie, not me."

GIRL NEXT DOOR

On the set that first day in May 1996, filming along New York City's posh Park Avenue, Katie recalled feeling much like a fish out of water. "I was totally clueless!" she told *Entertainment Tonight*. "Everyone—the makeup lady, the camera guys, had to explain everything to me. They must have thought I was a complete idiot!"

Ang Lee called her into his trailer to counsel her on her character—and Katie automatically assumed he was going to fire her. "That's how nervous I was," she said. "I thought, 'Okay, that's it. I'm history.'"

Of course she wasn't, and the role, although small, drew her critical praise. Her character, Libbets Casey, invites two boys (including Tobey, who plays Paul Hood) to her house over Thanksgiving vacation. Paul lusts after Libbets, and tries to get rid of the other guy (who also has the hots for her—wonder why!) by giving him sleeping pills. The plan, however, backfires when Libbets takes them, too—and then she comically crashes headfirst into Tobey's lap. "I didn't have experience with drugs," Katie later told *Ultimate TV.com*, "but I had

23

seen people who were drunk or high and they always acted really tired, so that's the way I went."

The film went on to win the best screenplay award at the 1997 Cannes Film Festival. Katie even attended the New York Film Festival premiere—her first official showbiz function. "It was a wonderful night where I was chatting with Kevin Kline and Sigourney Weaver," she told the *Copley News Service*. "I was kind of overwhelmed by it all, but it was nice to see how humble they acted offstage. And my feet hurt really badly because of my new shoes!"

"Making the movie was a lot of fun," she told *Teen* magazine. "But I didn't have a lot of faith I could make a living at this. It was hard work!"

After her first foray into moviemaking, which luckily had taken place over the summertime, Katie went back home to Toledo to finish her senior year of high school. Her teachers were a little worried that the experience might go to her head, so Katie made sure to let them know it was no big deal. "I downplayed it a lot,"

she said. "My friends of course were all excited and wanted to know what went down."

And it took only a few short months for Katie to forget the thrill of being a movie star. Like every other average teen, Katie was too busy stressing over SATs and final exams to even give much thought to a future in showbiz ("I thought, 'Acting is fun—now finish your homework' "). Then she heard through the casting grapevine that Kevin Williamson, the producer behind *Scream* and *I Know What You Did Last Summer*, was creating his first television show. It would be a teen coming-of-age story, a soap of sorts, with one big difference: The kids would be intelligent, mature, eloquent. They'd analyze and evaluate their relationships, question their parents' and teachers' ethics and morals, and deal realistically with the angst of adolescence. "I first thought, 'Wow, finally teenagers who are real teenagers,' " she told the *Fort Worth Star-Telegram*.

Okay, so maybe this wouldn't be such a bad gig to get. She'd have to see what she could do about her schedule. (She'd already

committed to the high school senior musical and was up to her ears in rehearsals.)

Meanwhile, back in Wilmington, North Carolina, Kevin was readying his set and searching for that special someone to play tart-tongued yet tender Josephine Potter. "It was like the role was just waiting for Katie to come and get it," Kevin told *Entertainment Tonight*. . . .

A Quick Kevin Williamson Quiz

1. What was the name of the North Carolina town Kevin was born in?
 a) Wilmington b) Dawson
 c) New Bern

2. What did Kevin do before he began writing movies and television shows?
 a) ran a seafood joint b) acted
 c) taught English

3. Who does Kev call his "honorary little sister"?
 a) Michelle Williams b) Drew Barrymore c) Katie Holmes

4. What director did Kevin team up with on *The Faculty*?
 a) Robert Rodriguez b) Jodie Foster c) Wes Craven

5. What college did Kevin attend?
 a) East Carolina University
 b) North Carolina University
 c) Columbia University

ANSWERS:
1. c
2. b
3. c
4. a
5. a

Wanted: The Perfect Pal Joey

"At one point during the audition, Katie and I looked at each other and said, 'Neither one of us is cool, so we don't have to worry. We can do this.'"
—JAMES VAN DER BEEK to the *Wellington Evening Post*

Katie couldn't believe her luck: Why did it have to be *now* that a great opportunity landed in her lap? *Dawson's Creek* sounded so cool—not your average no-brainer teenybopper television series—and she just had to give it a shot. "From the moment I read the script, I wanted to do it," she told *USA Today*. "I just loved it and I could relate to it so much. It captures the voice of teenagers so well."

Not able to take time off from her busy school and social life, she auditioned for *Dawson's Creek* not in person but with a

home video she shot in her mom's sewing room in their basement. Mom played Dawson to her Joey. ("Do you know how embarrassing it is to be reading lines like, 'Well, you have genitalia!' and 'How often do you walk your dog' [masturbate] to your mother?" she once groaned.)

Warner Brothers and the show's team were intrigued by her delivery (Katie's, not Mom's!) and asked her to fly down immediately for a screen test. "I will never forget that day when, after weeks of searching for the right actress, we got Katie's tape," *Creek* creator Kevin Williamson told *YM*. And he knew exactly what he was looking for, because the character he had created was an embodiment of his real childhood gal-pal-turned-high-school-sweetheart Fanny Norwood. "When I saw [Katie's] tape, my response was, 'How fast can we get her down here?' I was mesmerized, and I saw more than just Joey. I saw a star in the making."

In an unbelievable twist of fate, the date of her audition coincided with the opening night of her school play, *Damn Yankees!* Katie was the lead, playing the sultry Lola,

and she wasn't about to abandon her cast mates—even if it meant sacrificing a television series.

"My manager was freaking out, but I couldn't let all my friends down who had worked so hard on the play," she told the *Copley News Service*. So Katie actually said the timing wouldn't work for her. "Here was the only girl on this planet who would say, 'My friends mean more to me than being in this highly publicized series,'" Kevin later told the *Calgary Herald*. "It was heartbreaking—so we waited the week and flew her out."

And luckily for Katie, it paid off: The song she had sung in *Damn Yankees!* was "Whatever Lola wants, Lola gets," and the same came true for her. This time, when she flew down to audition in person, the jaded studio execs almost jumped out of their seats with joy.

"The first day I read twice for the studio," she recalled. "The second day I read three times for the WB network. That night I had the part." And it was Kevin Williamson who made the call himself. Katie was the perfect Joey—gorgeous,

guileless, and a girl who spoke her mind and followed her heart.

"She's full of talent and the camera loves her—you're drawn to her," he told *TV Guide*. "But beyond that, she's just a star in life. The type of person, I believe, who would be a success at anything she did."

He also sensed that she would click with her other costars—James Van Der Beek, Josh Jackson, and Michelle Williams.

And boy, was he right.

Katie's Favorite Things . . .

Guilty pleasures: Ben and Jerry's chocolate cookie dough ice cream; french fries; Starbucks vanilla latte (at least *once* a day!); Jelly Bellies ("don't tell my mom!"), especially the buttered popcorn flavor; pretzels with salsa.

What you'll always find in her fridge: Diet Coke, water, cookie dough.

Favorite reads: "Anything on Oprah's Book List"; *Fear and Loathing in Las Vegas* by Hunter S. Thompson; *Snow Falling on Cedars* by David Guterson; *To Kill a Mockingbird* by Harper Lee; and *The Awakening* by Kate Chopin.

Top tune players: Sarah McLachlan, Tracy Chapman, Frank Sinatra, Jewel, Natalie Merchant, The Dave Matthews Band.

Movie idols: Meg Ryan, Jodie Foster, Molly Ringwald.

Her first flick: *E.T.* (at a drive-in theater).

Fave films: Any of the brat pack films starring Molly Ringwald (*The Breakfast Club, Sixteen Candles, Pretty in Pink*), and *Titanic* ("I'm pathetic. I saw it, like, five times.").

Bad habit: "Long-distance phone calls. I'm always on the phone with my friends back in Toledo." She and best pal Meghann Birie, now a junior at Ohio State University, have been known to ring each other day and night.

Where you'll find her after hours: "At a karaoke bar. I'm addicted. Just put me in front of a microphone and crank up the soundtrack from *Grease* and I'm there!"

How she keeps her beanpole bod: Salads, vegetables, veggie burgers ("But I have to remember to hold the onion rings!"); exercise thirty minutes a day; plenty o' protein (smoothies with protein powder if she's too busy for a full meal).

A Creek Peek:
Life on the Set

"Sometimes when we read a script, I have to get my dictionary out."
—KATIE HOLMES

\mathcal{I}n May 1997, right after she graduated from high school with honors (she had a 3.8 GPA), Katie reported for duty to Wilmington, North Carolina (population 55,530). It wasn't exactly what she expected a glamorous television series set would look like: It was just a sleepy town with picket fences and a dock dotted with sailboats. But it was exactly what Kevin Williamson imagined Capeside to be.

"I wanted to invent this coastal town that had a New England feel to it," he told the *Virginian-Pilot*. "I wanted to create this

magical world, a living and breathing entity, that not a lot of people know about."

And as far as he was concerned, Wilmington would become home, ten months out of the year, to the cast and crew of *Dawson's Creek*.

The first day on any set is awkward and this was no different: Katie was younger than her two costars, James Van Der Beek and Josh Jackson, and immediately felt "green" in their presence. "They had both done a lot of work, movies and TV, and I had, like, one little role and school plays," she told the *Copley News Service*. Michelle Williams—though still only seventeen—was much more sophisticated and wordly, having lived in LA on her own. This was the first time Katie had ever lived away from her family. "I got teased mercilessly from the moment I walked in," Katie said.

"When the four of us get together, an instinctive dynamic develops," Josh told *Rolling Stone*. "Even though as human beings, I'd like to think we're a little broader than our characters, it's pretty close to what our characters would be doing."

"It's not like you're in this big city like

LA where you have tons of places to go and tons of people to hang out with," Michelle says. "You're with each other all the time in this small city, and you bond pretty quickly."

In fact, weekends are often spent en masse at Wilmington's nightclubs. "We try to get the boys to dance," Katie complained to *TV Guide*. "But they just get all embarrassed." Their fave restaurant is a place called Vinnie's. (An autographed photo of the Fab Four hangs on the wall and waitresses know them on a first-name basis.) All the actors have their own houses or condos now, but the first season, James and Josh shared a bachelor pad (and the girls often came over for pizza).

"Don't diss it! There's a lot to be said for Wilmington," Katie told *E!* "I'm from a small town, so it's nice to be here in a place like home. I mean, when we're not there, we miss the people and the restaurants, even though small town life can get, you know, a little dull 'cause there's not a lot to do. But it's so different from LA, no distractions of show business, no constant commotion."

Well, almost never. Sometimes shooting an episode goes into overtime, and the cast has to stay on set till the wee hours. That's when things can get a little crazy. "I'm more of a morning person," Katie told *Entertainment Weekly*. "So if we're working late at night, we're all exhausted, and we start talking about some strange things. You never know what's going to come out of people's mouths." Katie actually demonstrated on *The Tonight Show* with Jay Leno a trick she and her co-stars perfected while pulling one of those tough-to-get-through all-nighters: She can unwrap a Starburst candy in her mouth using just her tongue. (Jay wanted to know if that came in handy during kissing scenes!)

But no matter what the hour—or how weird the conversation—Katie is grateful for her *Creek* compadres. "I get to do what I love every single day with people I have incredible friendships with," Katie said in *YM*. "That's something that's pretty rare."

And her acting buddies obviously feel warmly about her as well.

What Her Co-Creekers Have to Say About Katie

- "Katie is the sweetest person, a true friend," Meredith Monroe (Andie) raved to *YM*. For example, when the pair first met, Katie asked her how long she would be on the show. When Meredith said she wasn't sure, Katie said another character had come on the show and was cut after only one episode. Then, she giggled, exclaimed, "Kidding!" and gave Meredith a big "welcome aboard" hug.

- "You could take her picture in the dark and she'd look good," Josh Jackson told *Seventeen*.

- "She's very sweet, very unassuming. I don't think she knows how beautiful she is," James Van Der Beek said in *People* magazine.

- "She is that rare jewel, the real deal," Kevin Williamson told *YM*. "In a word: hypnotic, smart, funny, sweet, shy, boisterous, sneaky, talented, pretty, soulful, sleek, sophisticated, innocent, naive, comical, womanly, childish, caring,

gracious, dependable, nurturing, protective, generous . . . I could go on."

A Typical Day on Dawson's Creek

5:45 A.M. Report to makeup and hair.

6:15 A.M. Report to wardrobe supervisor for appropriate costume (jeans, hooded sweatshirt, sneakers).

7 A.M. Filming on location at "Capeside High," a.k.a. the University of North Carolina at Wilmington campus. Hallway and classroom scenes require about fifty extras, who are already lined up and trying to catch a glimpse of the cast.

8 A.M. Locker scene in the nursing school (Hoggard Hall). After eight takes, the team nails it.

10 A.M. Several scenes on the campus grounds. Though the cast is dressed in casual spring attire—shorts, tee shirts, little sun dresses—it's actually a chilly fall day. They shiver between takes.

Noon. Lunch (catered for the cast and crew). Katie scarfs down a veggie burger.

2 P.M. Exterior at the Leery's. Storm

clouds overhead look ominous, which may mean a change of plans for shooting. . . .

5 P.M. Back to the Screen Gems soundstage to shoot scenes inside Dawson's house. Katie climbs the ladder to his bedroom window—which is only a few feet off the ground. A good thing, she says, because she's "a klutz."

9 P.M. That's a wrap. Luckily, this episode didn't require too much overtime. "There are days," Katie says, "where things aren't working and we'll be shooting, like, forever."

Dawson *Devotees*

- **Check out these official Web sites, dedicated to the show:**

 www.dawsons-creek.com The official site.
 www.spe.sony.com/tv/shows/dawson/ The Sony TV site. An added plus—you can get weekly emails from Dawson!

- **Unofficial (nevertheless, awesome) fansites:**

 www.angelfire.com/sc/samra
 www.geocities.com/Hollywood/Picture/7455/
 www.geocities.com/Hollywood/Hills/7706/dawsonscreek.html
 www.geocities.com/SouthBeach/Palms/9334/
 www.geocities.com/TelevisionCity/Set/9347/DC.html
 www.geocities.com/TelevisionCity/Set/6283/
 www.geocities.com/TelevisionCity/Set/1630/
 www.netpathway.com/~jgunn/dcreek/
 http://members.aol.com/dawson0415/dawson.htm
 members.xoom.com/DawsonsCreek/

- **More books to browse:**
 Meet the Stars of Dawson's Creek by Angie Nichols (Scholastic)

 Way Too Much Information: A Fanatic's Guide to Dawson's Creek by Sheryl Altman (HarperActive)

 Meet the Stars of Dawson's Creek by Grace Catalano (Bantam)

 The Stars of Dawson's Creek by Hilary Rice (Infinity Plus One Llc.)

 Dawson's Creek: *The Beginning of Everything Else* by Jennifer Baker (Archway)

 Boy Next Door: The James Van Der Beek Story by Alex Tresniowski (Ballantine Books)

 *Long Hot Summer (*Dawson's Creek, *No. 1)* by K. S. Rodriguez, Kevin Williamson (Pocket Books)

 *Calm Before the Storm (*Dawson's Creek, *No. 2)* by Jennifer Baker, et al. (Pocket Books)

 *Shifting into Overdrive (*Dawson's Creek, *No. 3)* by C. J. Anders, Kevin Williamson (Pocket Books)

 *Major Meltdown (*Dawson's Creek, *No. 4)* by K. S. Rodriguez, Kevin Williamson (Pocket Books)

Double Exposure (Dawson's Creek, *No. 5)* by C. J. Anders (Pocket Books)
Trouble in Paradise (Dawson's Creek, *No. 6)* by C. J. Anders (Pocket Books)

- **Groove with the gang:**
 Songs from Dawson's Creek/Various Artists (Sony/Columbia Records)

TV's Top Teens

"You're big now, you're huge. This thing went nuts, didn't it?"
 —DAVID LETTERMAN

*E*ven before its first episode aired, *Dawson's Creek* was a hit. Katie, James, Josh, and Michelle had their faces plastered all over billboards and magazine covers. The show's theme song "I Don't Want to Wait" by Paula Cole was climbing up the charts (helped by the WB's constant commercials). From just a few minutes of trailer, you got a picture of what was in store: The dialogue was racy, and the plots—Well . . . let's just put it this way: In the first episode, a student was contemplating sex with his teacher. (In

the second, he closed the deal.) There was psychobabble, dysfunctional families, and Spielberg references galore. Slasher king Kevin Williamson had created another monster; after viewing only the pilot episode, critics cheered and couldn't get enough of it. *Teen* magazine dubbed *Dawson's Creek* a "sizzling teen saga" and *Knight Ridder News* heralded "There's no hotter property."

The same, of course, could be said for the four leading actors from the moment audiences got their first glimpse of Capeside.

"It was crazy," Katie confided to *E!* "It's like all of a sudden, everyone wanted to know who we were. I felt like a deer caught in the headlights. I did struggle for a while with the guilt. I mean, why did this happen to me? Why didn't I suffer for five years like other actors? Why am I any different than anyone else? I was extremely fortunate—I didn't have to wait tables in LA and go on thousands of auditions."

And of course, once the actors were established as personalities who could pull

in millions of teen viewers each week (according to the Nielsens, it's number one among girls ages twelve to seventeen, and has helped the WB's ratings soar), the big-screen offers started pouring in.

"Not since *Friends* has a hit TV show inspired such frenzied attempts to turn small screen celebs into big box office draws," wrote *Entertainment Weekly*. Add to all this mega-merchandising: Tee shirts, baseball hats, posters, books, CDs—plus Web sites, fan clubs, and enough press coverage to launch a presidential campaign.

"It was a dream," Katie told *Ultimate TV.com* shortly after the show's premiere. "Going from a high school musical to this pilot. Getting to meet all these people. Forming all these friendships. Being at the center of all this buzz. . . ."

What Do Her Neighbors Think?

Having the hottest television show on the planet filming right in their own back-yard has caused quite a stir among the Wilmington, North Carolina, natives as

well. Almost everyone, from the guy who fixes transmissions to the local librarian, has had a *Dawson's Creek* cast encounter by now.

"The show's really been wonderful for Wilmington," says Connie Nelson, spokesperson for the Cape Fear Coast Convention and Visitor's Bureau. As you might imagine, fans are flocking to the coastal town, making it a *hot* vacation spot any time of the year. The Visitors Center has even issued a *Dawson's Creek* FAQ sheet and will help you organize your very own self-guided tour (see the end of this chapter).

"Young people are very excited about it and are urging their families to come here just so they can experience the places the characters hang out," Connie adds. "But of course, we do have a lot to offer besides the *Dawson's Creek* connection—beautiful beaches, fun water activities, charming shops and restaurants . . ."

Kevin Williamson, a North Carolina native, certainly thinks so. "Wilmington is exactly the way I envisioned Capeside," he

has said. "A New England coastal town, quaint and very all-American."

And locals were thrilled to see their streets and homes on national television every week. "It generated a lot of excitement—we're all *Dawson's Creek* devotees now," Connie continues. "We never miss an episode and we feel like we know Dawson, Joey, Pacey, and Jen firsthand."

Wilmington residents are proud to point out all the places the fictitious teens tend to frequent. "We're always asked where you can see Dawson or Joey in town," Connie says. "While the sets are closed, there's a very good chance you might just bump into them at a local restaurant or on the college campus. And if you ask any Wilmington resident, you can bet they have a great story to tell!"

Just ask David Kubes, manager of Elijah's restaurant on Chandler's Wharf, who claims to have had multiple Katie sightings. "She comes in here a lot for lunch," he says. "She's always very nice to people, very normal. It's not unusual to see the *Dawson's Creek* cast just hanging, eating outside on the deck overlooking the

river." And what's Ms. Holmes' idea of delicious hometown cooking? "Pretty much anything," David says. "BLT, barbeque, chicken sandwich, a burger. Although like everyone else in town, she likes our specialty: hot crab dip on garlic bread." The recipe for this local delicacy, David insists, is "a trade secret—although the whole cast has tried to get it out of us!"

"Dawson and Pacey used to live right upstairs," says John Malejan, owner of Café Deluxe on Market Street. "The first season, those two guys were sharing an apartment, and the cast would often come in here for dinner." Josh, he says, always requested dishes without nuts (he's allergic) and loved to scarf down tempura shrimp with wasabi. Katie, he recalls, was "super down-to-earth" and always gracious if a kid came over and asked for her autograph.

"But that didn't happen too often," John recalls. "Because people really do respect their privacy and understand that they're just regular people, doing a job. We basically accepted them as members of our community."

GIRL NEXT DOOR

Don Betz, former mayor of Wilmington and now publisher of *Wilmington Magazine*, says no one in the city acts starstruck, even if they come face to face with Katie. "We've been used to movies being shot around the area—both *Cape Fear* and *Firestarter* were filmed here," he says. "So we welcome actors and production crews. We have a beautiful home here, and we're happy to share it."

In fact, according to the Visitor's Bureau, since 1983, more than four hundred movies and television projects have been shot in Wilmington. "We affectionately refer to it as Hollywood East," adds Connie. "And we're proud now to be depicted as Capeside." But where should you visit if you manage to make a personal visit to Wilmington, North Carolina?

Take the Tour!

According to Connie Nelson, here are the spots any *Creek* fan should see in Wilmington. (For more information, write or

call the Visitor's Bureau, 24 North 3rd Street, Wilmington, NC 28401 901-341-4030, or check out its Web site at *www.cape-fear.nc.us*. They'll be happy to help you out!)

- **The University of North Carolina,** a.k.a. Capeside High. If the front steps to Alderman Hall look familiar, it's because that's where Dawson and Joey usually meet before walking home from school, says Connie. Randall Library, Greene Track and Field, Hanover Gym (remember that episode where Dawson bounces a ball off Pacey's nose?) and Hoggard and Hinton James Halls are all used in the show. *Creek* films from January through March and July through December. University students often watch the episodes being shot and even make some money (about $6 an hour) as extras. Campus tours are permitted (call University Relations at 910-962-3861 or check out the Web site at *www.uncwil.edu*). And if you're a budding Spielberg like Dawson you may even want to consider enrolling in UNCW's Film Studies pro-

gram for a firsthand education in how movies are made.

- **Screen Gems Studios** (1223 North 23rd Street). You can take a guided studio tour on most weekends (cost is about $10), and you might even be lucky enough to get a gander of the Leery house or Dawson's bedroom set on the soundstages. Call 910-675-8479 for more information.
- **The Icehouse Restaurant and Beer Garden** (115 South Water Street).
- **Screen Play Video** (212 North Front Street).
- **Mollye's Market** (118 Princess Street), a frequent Capeside hangout.
- **Island Passage Elixir** (1 Market Street) was the boutique in the episode "Full Moon Rising."
- **Thalian Hall Center for the Performing Arts** (310 Chestnut Street) served as the interior for the Rialto Theater.
- **The Cape Fear Riverfront Visitor Information Booth** (at Market and Water Streets) appeared as a hot dog stand on the show.

KATIE HOLMES

- **Riverfront Park** (Water Street, across from the courthouse) is where Andie and Pacey first locked lips.
- **Battleship Park on Eagle's Island** was the site of the Winter Fair in the "Psychic Friends" episode.
- **Banks Channel and Wrightsville Beach** have been used for various dock shots.
- **Greenfield Lake** (1702 Burnett Blvd.) doubles as Burham Lake on the show.
- **The Hollywood Connection Café** (1223 North 23rd Street) studio commisary sells *Dawson's Creek* memorabilia. (What trip would be complete without a souvenir?)

Other haunts where the cast likes to convene after hours:

- **Water Street Restaurant** (5 South Water Street, 910-343-0042). It offers a fabulous view of the river and battleship. You can munch your lunch on the sidewalk patio.
- **Front Street Brewery** (9 North Front

Street, 910-251-1935). For casual eats and the best beer in town (brewed right there!).

- **Pizza Bistro** (319 North Front Street, 910-762-1222). Who could resist a surf-and-turf pie with anchovies? You name it, they put it on a pizza.

Other fun spots to check out:

- **Wilmington Railroad Museum** (910-763-2634). Nothin' like a little trip down the tracks of years past (and it's a real crowd-pleaser for your little brothers and sisters).
- **The Cape Fear Museum** (910-341-7413). The Michael Jordan Discovery Gallery (he's a native, you know) has interactive activities for all ages.
- **The USS** *Battleship North Carolina* (910-350-1817). Explore the nine decks of this mammoth ship including the galley, sleeping quarters, and the King-fisher float plane.
- **Carolina Beach.** Not just for catching some rays. Check out the Jubilee Park

(complete with rides and waterslides,
910-458-9017) and the famous board-
walk.

The Personals on Paula

Along with the *Creek* cast, musician Paula Cole found herself propelled to instant stardom, thanks—in part—to the show's ever-present theme song. (Katie, by the way, is also a big fan of Paula's.)

According to her official bio, Paula was born in Rockport, Massachusetts, on April 5, 1968. She's been into music since she was a tot—her dad was in a *polka* band! She was one of the most popular kids in high school, pulling straight A's as well as being elected class president and Homecoming Queen. Her first album, *Harbinger*, hardly caused a stir, but in 1995, *This Fire* burned up the charts (it includes "Where Have All the Cowboys Gone?" and "I Don't Want to Wait"). Her latest album (which you can bet will be played on several *Creek* episodes) was released in September of 1999.

Will the Real Joey Potter Please Stand Up?

"Unlike Joey, I've had the quintessential upbringing—we never really had too much drama."

—KATIE HOLMES

\mathcal{Y}ou have to admit, it would be pretty easy to confuse Katie with her series character: Both grew up in small towns, both were the youngest in their families, and both have a no-nonsense approach to everything from the male psyche to makeup.

"I guess, like Joey, I thought I knew everything," Katie once commented. "Like her, I made a lot of mistakes, but fortunately I haven't had the tragedy that she's experienced in her life."

If you need a refresher, here's a brief rundown of Joey Potter's problems these

past few seasons: She's had to deal with a deadbeat dad who's in jail for drug dealing, the death of her mom from cancer, and a sister who had a biracial baby out of wedlock, along with debt up to her ears, a thankless job scrubbing greasy grills and waiting tables, a boyfriend who recently came out of the closet, a backstabbing vixen who moves in on her man, and, of course, her on again/off again romance with Dawson. (Which is the result of raging hormones that turned her childhood pal into an object of desire—and gives the term "play-date" a whole new meaning!)

Katie may not be able to relate (thankfully!) to all of the above, but she thinks she understands what makes Joey tick and the reason she's so smart-mouthed and sarcastic all the time: "She has to come back with her wit," she told *Seventeen*. "It's the only way she knows how to deal with her pathetic existence."

"She's full of emotions," Katie discussed with *E! Online*. "I'm like her in that we both say what we feel, but Joey goes a little further." How much further? Well,

how about asking Jen what color hair dye she uses? Or accusing Dawson of being so far removed from reality that he can't see what's right in front of him (namely *her*)?

"Joey can say some pretty tough things—but they're always honest," Katie has explained. That's because Joey admits exactly how she feels at exactly the moment she feels it. "I'm actually working on becoming more like my character," Katie confessed to *Us*. "She's so smart and strong."

But behind all those zingers is a fragile vulnerability. "I get that about her," Katie told *E!* "But you know, sometimes, when you're insecure, you have to pretend you're not so people don't see through you. So they can't hurt you. That's her defense."

The hard part, however, is when fans don't realize she and Joey aren't one and the same. "Sometimes a kid will come up to me and be like, 'Gee, I'm really sorry about the fight you had with Dawson, I hope you work it out,'" she told the *Virginian-Pilot* recently. "And I'm like, 'Well, you know that's really only on TV. James

and I aren't really in a fight or anything. . . ." Besides, she told the *Fort Worth Star-Telegram*, her mom would "have never let me have a sleepover with a friend who was a boy. That's just too much!"

As is the idol worship thing, which can go a bit too far. "I feel so stupid when little girls come up to me and tell me they admire me," she told *Life*. "I'm not doing anything. There are people doing really good things in the world—I'm just having a blast."

Katie was also a bit alarmed when she opened up a recent story in *Rolling Stone* (she appeared on the cover swinging on a tire, billed as America's sweetheart) and read all about her relationship with Josh Jackson. "Suddenly, most of my life was out there," she told *TV Guide*. "Why do people want to know all of this?"

If anyone can handle it, she can, Josh responded. "Katie carries herself with a grace that really belies the fact that she's only been working for a year and a half. She's a wonder to behold."

But, insists Katie, she has a lot of responsibility to shoulder. "It's so scary when you

think of all these kids looking up to you, doing what you do," she told *TV Guide*. "It's like all the world is watching."

Katie vs. Joey: A Quick Comparison

Joey	Katie
Homelife from hell	"At the holidays, we're like a Norman Rockwell painting"
Her best bud—Dawson Leery—became her beau	Her beau—Josh Jackson—became her best bud
Works at the Icehouse	Starred in *The Ice Storm*
Performs Broadway showtunes ("On My Own" from *Les Misérables*)	Performs Broadway showtunes ("Whatever Lola Wants" from *Damn Yankees!*)
Totally athletic tomboy: able to climb a trellis, row a boat, outrun Dawson	"Zero athletic ability—I'm a klutz"

Sole sibling with tons of responsibility, including babysitting her big sister's kid	Youngest of five: "Everyone watched over me and babied me."
Ponders a career in art	Pondered a career in medicine
Tough as nails	Bites her nails
The queen of the snappy comeback	"If someone says something mean . . . I'm, like, totally speechless."

Did You Catch Katie . . .

- on the covers of *Rolling Stone*, *Teen*, *Seventeen*, *YM*, *TV Guide*, and *Entertainment Weekly*?
- chatting with Jay Leno and David Letterman?
- photographed by Annie Leibovitz for *Vanity Fair*?
- at the Emmys and Nickelodeon's Kids' Choice Awards?

Her Leading Men

"I just think love scenes are better with nice breath."
—KATIE HOLMES

"She is a good kisser . . ."
—JAMES VAN DER BEEK

*B*oth on- and offscreen, romantically and platonically, Katie has been lucky enough to know some pretty great (and great-looking) guys. Still, she's selective: "I'm more apt to go for a dark-haired man," Katie confided to *Rolling Stone*. "Someone who's intelligent but not showy, especially in this business."

"I'm a private person—not a big socializer," she commented to *Teen* magazine. "I'm a little shy, but also friendly. Those are the same qualities I look for in a guy."

No doubt, there are dozens who fit this

bill—and would eagerly volunteer to be Katie's cutie. But amazingly, she isn't looking for love . . . just yet. "I don't really think about marriage or having kids," she has said. "I just had my first serious boyfriend last year. I don't really feel like I have to rush that stuff."

In high school, she dated—but not that often. "In that way, I'm a lot like Joey," she told *Seventeen*. "She doesn't get all the guys and neither did I." Katie always seemed to go for the same type of boy: "The unattainable, popular athletes. Dances were terrible, because we'd have to ask them out. Let me tell you, there were no big romances for me."

Things are a little bit different today: Fan letters flood in weekly ("I've even had a few marriage proposals"), but she'll keep holding out for the perfect Prince Charming. *Creek* devotees were rooting for Josh Jackson to be Mr. Right (he was that "first serious boyfriend" Katie mentioned above), but alas, Katie finally passed. "Josh and I dated," she confessed to *TV Guide* (naming names for the first time). "We're both single now. And everything's nice. It

was pleasant. It was wonderful." Now they're just pals.

Her approach to winning a guy's affection is to "totally ignore him." And that advice, she says, comes from experience. As does her idea of the most romantic date: "One time I got caught in a rainstorm with somebody, and we were dancing in the street . . ." she told *YM*.

Such is the stuff that makes Katie Holmes swoon.

The Men in Her Life

Joshua Jackson
Born: June 11, 1978
Hails from: Vancouver, British Columbia

Career highlights: all three *Mighty Ducks* movies, *Magic in the Water, Andre the Seal, Digger, Tombstone, Crooked Hearts, Scream 2, Apt Pupil, Cruel Intentions, Urban Legend*; TV: *Robin of Locksley* and *Ronnie and Julie* (Showtime), *Champs, The Outer Limits.* In the upcoming suspense thriller, *The Skulls,* from Universal Pictures, he plays Luke, an "overachieving New Haven townie clawing his way into an Ivy League college." When he joins an elitist society—The Skulls—he becomes trapped in "a life-and-death game."

The Katie connection: He plays Pacey to her Joey on *Dawson's Creek,* which led to a real-life romance last year. It started out, Katie recalled, with just a few childish pranks—"I saw Josh's butt more times than I care to admit! He was always moon-

ing me"—then blossomed into a genuine affection.

Do blondes have more fun? "Hair color has nothing to do with it," Josh told *YM* after dyeing his locks a lovely shade of platinum for a horror flick. Besides, he said, "I would never do it again—it took six hours, and it hurt!"

Girls he considers gorgeous: Halle Berry, Uma Thurman, and, of course, Katie: "Yeah, she's real hard on the eyes," he jokingly complained to *E!*

The music that moves him: Rappers Gang Starr and Common Sense.

Katie's commentary: Think about it— how would you respond to someone *you* worked with every day, especially if he was over six feet tall and had blue eyes and a Caesar haircut? How could Katie resist? "I fell in love, I had my first love, and it was something incredible and indescribable that I will always treasure," she revealed in *Rolling Stone*. "I feel so

fortunate because he's now one of my best friends. It's weird—it's almost like a Dawson and Joey–type thing now. He's been in the business so long and he's really helped me. I respect him as a friend and as a professional."

Web sites to watch:

- Unofficial fan tributes to the handsome Joshua Jackson abound!

 www.geocities.com/Hollywood/Theater/4300

 www.geocities.com/Hollywood/Cinema/1634/

 www.geocities.com/SouthBeach/Palms/7705/joshua.html

 www.alysia.com/foxy1foxy1/cjjackson.htm

 http://homepages.lycos.com/MarLev/lycelebrity/JoshJack.html

 http://homepages.lycos.com/Babyblu14/lycelebrity/

 http://homepages.lycos.com/Nikki87/lycelebrity/www.html

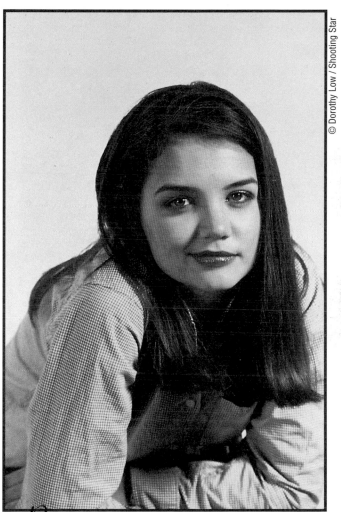

*P*hotographers say Katie is a natural in front of the cameras—and here's proof.

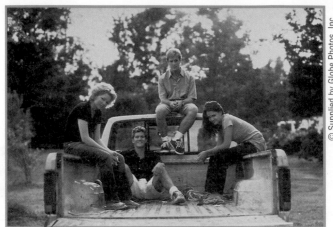

*K*atie and her Creek crew: James Van Der Beek, Joshua Jackson, and Michelle Williams.

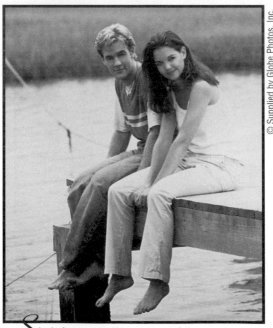

*S*ittin' pretty: Dawson and Joey on the creek.

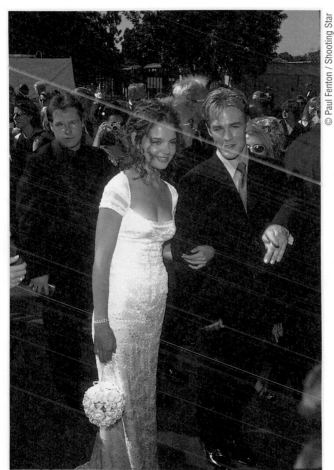

\mathcal{W}hen James brought Katie to the Emmys, it fueled rumors of romance, but the pair is strictly platonic.

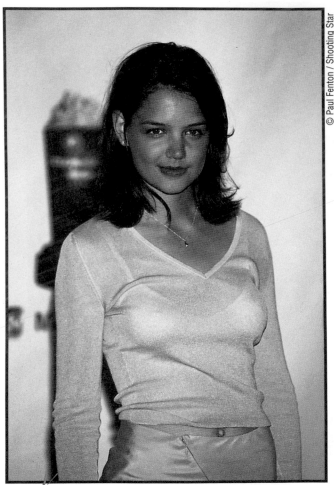

*K*atie is sleek and chic in a sheer shirt with a plunging neckline.

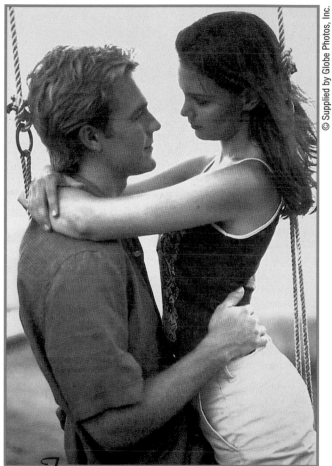

The on-again/off-again romance of Joey and Dawson keeps fans tuned in every week.

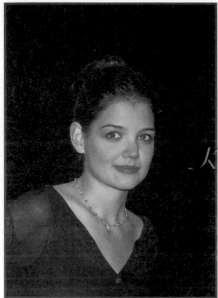

*K*atie sports an elegant updo at the Nickelodeon Awards.

*K*evin Williamson plants a kiss on his pal Joey.

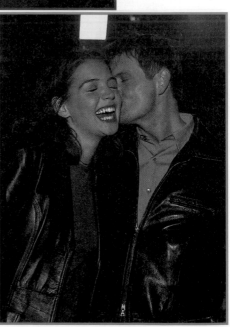

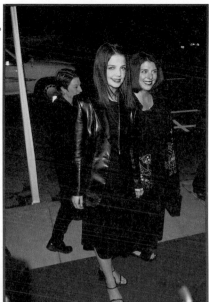

© Paul Fenton / Shooting Star

*F*amily ties: Who better than a big sis (right) to hang with?

© John Kelly / Retna Limited, USA

*W*hite hot: Katie goes glam at the 50th Annual Emmy Awards.

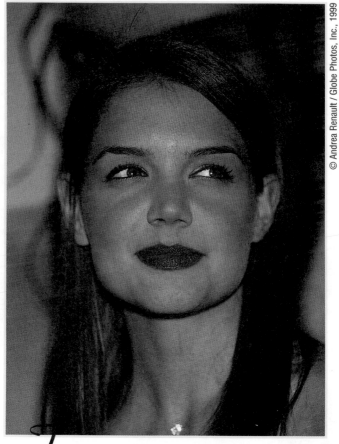

*F*resh-faced beauty minus the fuss is Katie's philosophy.

James Van Der Beek
Born: March 8, 1977
Hails from: Cheshire, Connecticut

The Katie connection: They've locked lips more times than we can count on *Dawson's Creek* and have been seen together (all dolled up and holding hands) at a few award shows. So . . . could life one day imitate art?

Career highlights: *Finding the Sun* (an off-Broadway play); *Shenandoah* (yes, he sings) at the Goodspeed Opera House; *Clarisa Explains It All* (TV); *Angus; Varsity Blues; I Love You, I Love You Not* (with Claire Daines); *Harvest.*

The music that moves him: The Dave Matthews Band, Natalie Imbruglia, and his own guitar grooves (he's teaching himself to play).

Katie's commentary: "He makes it all really easy for you—even the awkward stuff," she told *E!* "He's really a great guy, really fun to work with and be with."

Katie the comic: She once locked James and Josh outside their hotel room. Both were wearing just their boxer shorts, and "Boy," she says, "were they mad!"

Van Der Beek speaks: "Katie's beautiful, but not Barbie-doll beautiful. And that's even better."

Web sites to watch:
http://mrshowbiz.go.com/people/ jamesvanderbeek
http://moviething.com/biographies/ JamesVanDerBeek/
http://surf.to/vanderbeek
http://members.delphi.com/chibi/ index.html
http://members.tripod.com/~jvdb/

Tobey Maguire
Born: June 27, 1975
Hails from: Santa Monica, California

The Katie connection: Found himself in a compromising position with Katie in *The Ice Storm* ("I just closed my eyes and didn't think about her head landing in my lap," he once admitted). Happily enough, he will reteam with her in *Wonder Boys* in 1999.

Career highlights: *This Boy's Life* (with "partner in crime" and best bud Leonardo DiCaprio), *S.W.F.*, *Revenge of the Red Baron*, *Empire Records*, *The Duke of Groove*, *Joyride*, *Deconstructing Harry*, *Pleasantville*, *Fear and Loathing in Las Vegas*; TV series: *Jake and the Fat Man*, *Parenthood*, *Roseanne*, *Erie*, *Indiana*, *Blossom*, *Walker, Texas Ranger*; TV movies: *Spoils of War*, *A Child's Cry for Help*, *Seduced by Madness*.

How he got his start: As a cute kid in commercials for McDonald's, Doritos, and Atari.

How he sees himself: "A cross some-where between Tom Hanks and John Malkovich," he told *Premiere*.

Web sites to watch:
http://www.geocities.com/Hollywood/ Bungalow/5317/
http://www.mindspring.com/~gish/ tobeyweb/
http://www.geocities.com/Hollywood/ Hills/1670/tobey.html

James Marsden
Born: September 18, 1973
He hails from: Stillwater, Oklahoma

The Katie connection: costarred with her in *Disturbing Behavior* as new-kid-on-the-block Steve.

Pre-DB work: starred with Nastassia Kinski and Vanessa Redgrave in the CBS miniseries *Bella Mafia*; appeared on the television series *Second Noah, 919 Fifth Avenue, Boogie's Diner, The Nanny, Touched by an Angel, Blossom,* and *The Outer Limits*; Movies: *Bloody Barkers and The Gift* (HBO), *Ambush in Waco, Taken Away, Search and Rescue, On the Edge of Innocence.*

His dream date: "Someone you can be best friends with," he told *YM*.

Screen idol: "Paul Newman. He does a lot more than just make women swoon."

Most embarrassing moment: Getting naked (well, almost—he wore a tiny Speedo)

in the front seat of a pickup with Katie on camera.

Is he taken?: Judge for yourself: "I love my girlfriend to death."

Katie's commentary: "Jimmy and I got along great," she told *YM*. "I hung out a lot with him. He imitated other people, and he would get these cheesy romance novels off the set and pretend they were his, just to crack people up."

Web site to watch:
www.geocities.com/Hollywood/Theater/ 5207/ A fab fan tribute.

Barry Watson
Born: April 23, 1974
Hails from: Traverse City, Michigan

The Katie connection: Costars with her as Luke in *Teaching Mrs. Tingle*. "He's the carefree, doesn't-give-a-rat's-ass type," he told *YM* about his character. And Katie? "Definitely the coolest."

Career highlights: plays Matt Camden on the television series *7th Heaven*; *Baywatch*.

His dream date: Dark hair, about 5′6″ or 5′7″, honest with herself and others (sound familiar?). "Oh yeah—and her name would have to be Lauren." (Shucks! That's his steady girlfriend.)

Katie's commentary: "Barry and I are great friends, so it was kind of weird to be making out and ripping your clothes off with your good buddy," she told the *New York Daily News*.

Web sites to watch:
http://www.geocities.com/Hollywood/Bungalow/9986
http://silverweb.com/krjp/Barry Watson
http://members.tripod.com/rewoper/barry.html

Nick Stahl
Born: December 5, 1979
Hails from: Dallas, Texas

The Katie connection: Played fellow outcast Gavin in *Disturbing Behavior*.

Fave pet: A bullfrog he purchased with his salary from *The Man Without a Face*.

Pre-DB work: *The Thin Red Line*; *The Man Without a Face* (costarred with Mel Gibson); *Eye of God; Safe Passage* with Susan Sarandon and Sam Shepard; *Tall Tale* with Patrick Swayze; Made-for-television movies in 1991 and 1992: *Stranger at My Door* and *Woman with a Past*; CBS miniseries *Seasons of Love*.

Upcoming projects: *Backwards Looks, Far Corners, Sunset Strip, Johnny Hit and Run Pauline*, and *All Forgotten*.

Web sites to watch:
www.NickStahl.com
http://www.geocities.com/Hollywood/Makeup/3792

Beyond the Creek: Her Big Screen Career

"What could be cooler? I'm working with Katie Holmes and a six-foot decaying corpse."
—BARRY WATSON to
the *Chicago Tribune*

\mathcal{A}fter wrapping the first thirteen episodes of *Dawson's Creek*, it was time for Katie to try her luck once again in movies. The offers were certainly pouring in for all the actors, and it was just a question of finding the right scripts, the right projects. James would star in a football drama, *Varsity Blues;* Michelle Williams went off to film *Halloween 3* with Jamie Lee Curtis; and Josh accepted a small part (as a gay student) in the deliciously malicious *Cruel Intentions* with fellow WB-er Sarah Michelle Geller. It only made sense that

Katie would try to spread her acting wings in the same way.

"Katie has more latent ability than anybody I've ever worked with," Josh Jackson once told *Rolling Stone*. "The onus is now on her to turn into Meryl Streep and not rest on her laurels."

Which is the last thing she would do. Katie never assumes that her stardom is cemented. Far from it: "Today, we're really popular, but you never know. Some new show could be big next year and I'll be back in Toledo," she kidded with Jay Leno in 1998.

So rather than sit back and enjoy all the perks of being named this year's "It" girl, she's eager to work hard, even during those few weeks a year she isn't filming the series. "I'm not a workaholic or anything," Katie insists. "I'd be really happy to just hang out at the mall!" But instead, she keeps challenging herself and her fans (not to mention her poor parents' blood pressure!) with new projects and new roles.

"You can't just keep playing the same type of character your whole career," she

told MTV. "I mean, that would get boring. Maybe this isn't how *Dawson's Creek* fans would expect to see me, and I think that's okay, you know? I mean, I'm not just Joey."

Which isn't to say finding time to film a major motion picture is easy for her: *Dawson's Creek* can be pretty demanding and she often has to turn down movies she'd love to make. "I do movies during my hiatus," she told *E!* "It's, like, the only time I can! But it's worth all the work if I can express a new side of myself and if I can learn something in the process."

Katie's Filmography

Disturbing Behavior (1998)

The plot: In Cradle Bay, teenagers are so straight-laced, they give Donny and Marie a bad name. No drugs, no drinking, no sex. They're probably not even allowed to watch *Dawson's Creek*! What do these kids do for kicks? Can you say "bake sale"?

Where Katie comes in: She's Rachel Wagner, a black-clad, bare-midriffed social misfit. Along with pals Steve and Gavin, she's suspicious of her peers' disturbing behavior (hence the flick's title). They discover that a group of kids has been brainwashed and programmed to be the perfect students (called The Blue Ribbon Club). Now the trio has to battle the school shrink, who wants to silence them with a surgical procedure that will turn them into Stepfordlike do-gooders.

The scoop: Chills, thrills, and Katie playing a bad, bad girl. Also, you're not just imagining the *X-Files* feel to this flick—some of the show's alums worked on it (director David Nutter, director of pho-

tography **John** Bartley, and composer Mark Snow).

The verdict: So-so reviews, but Katie "keeps your butt in your seat," according to critics. Mr. Holmes (Katie's pop) had his own opinions: He worried that this movie might ruin his daughter's pristine rep (pierced body parts and lines like "Bite me!" can do that to a girl). What would the nuns back home think?

Katie's commentary: Why she'd choose this role as a breakout from *Creek*? "My character in *Disturbing Behavior* was totally different from anyone I've ever played," Katie explained to *YM*. "She's the wrong-side-of-the-tracks kind of girl who has experienced so much. It was kind of a dark story, and we shot it in Vancouver on a lot of nights when it was cold and rainy. It was also my first major love scene—I giggled a lot."

Web sites to watch: *http://www.Disturbing-Behavior.com/* The official site.

Applause, applause: Katie won the 1998 MTV Movie Award for Best Breakthrough Female Performance for *Disturbing Behavior*.

Go! (1998)

The plot: In this low-budget indie flick about a drug deal gone bad, Katie plays supermarket checkout girl Claire Montgomery who, along with her pal actor Sarah Polley, gets herself in a whole lotta trouble. It costars *Party of Five*'s Scott Wolf and presents a crime from three different perspectives.

Katie's commentary: "It's raw—like *Pulp Fiction*," she told MTV.

Worth watching for: The heavy makeout session she has with the drug dealer, played by Timothy Olyphant. "I was a wreck worrying about it," she confessed to *E!* "But once we got into it, I was okay. It's just, you know, all of these people watching!"

The verdict: Mediocre mass-media reviews, but it made quite a splash when it premiered at the Sundance Film Festival.

On working with Wolf: "I had a major crush on him," Katie once commented. "He came up behind me and was like, 'Hi, Katie.' We were talking. I was, like, beaming. You know when you're at a high

school party and the cutest guy walks up to you?"

Web sites to watch:

http://www.spe.sony.com/movies/go/
The official Web site for *Go!*
http://www.sundancechannel.com/ festival99/filmguide/premieres/goooo. tin Go!'s Sundance premiere.

Teaching Mrs. Tingle (1999)

The plot: Leigh Ann Prescott, a valedictorian wannabe (our girl Katie), gets framed as a cheater. When her history teach (the title's Mrs. Tingle) refuses to see her side of the story and threatens to give her a C, she and her pals (Barry Watson and Marisa Coughlan) hatch a homicidal plan.

Kevin's call: This was our buddy Williamson's directorial debut (he also wrote it). He describes the film as "a very dark comedy, a little wicked and malicious, but not a horror film." It is also, he admits, semiautobiographical. Wow, wouldn't you just *hate* to be in this guy's homeroom?

Katie's commentary: "My favorite movie

when I was growing up was *Pretty in Pink*," she confessed to *Entertainment Weekly Online*. So while working with Molly Ringwald on *Teaching Mrs. Tingle*, she was completely starstruck. "It was so bizarre having lunch with her," Katie added. "I told her I was a big fan. She was probably thinking the whole time, 'You're such a freak.' "

On her steamy scene: "It was awkward to have all these teamsters watch me take my shirt off," she told the *Calgary Herald*. "And they're just standing there, yawning and eating donuts."

Lovin' Leigh Ann: "She's the strongest female character I've ever played," she told *YM*. "There are so many factors in her life working against her that she should use as excuses for not reaching her goals. Yet inside, she chooses to overcome her obstacles and achieve her dreams. She's a fighter."

Making the grade: "Katie was the consummate professional," Helen Mirren told the *Calgary Herald*. "She is technically able as an actress, and experienced. She is also the sweetest girl on the planet."

Some *Tingle* trivia:

- The movie was also "loosely based" on the young adult novel *Killing Mr. Griffin* by Lois Duncan (Dell).
- The title was changed from the original *Killing Mrs. Tingle* to seem less scary and more humorous.

Web sites to watch:

www.dimensionfilms.com/mmfront/owa/ dim movie page.body?midStr=1182 The official site.

http://members.xoom.com/kmtsite/ Dedicated fan page.

The Leigh Ann Look

Costume designer Susie DeSanto told *W Magazine* she shopped at Agnes B., Madison, American Rag, and Fred Segal in Los Angeles to create "Marilyn Monroe/Bridgitte Bardot kinds of 50s movie star silhouettes" for Katie in *Teaching Mrs. Tingle*. Some of the items she snatched up: platform shoes, pedal pushers, and capris. Katie's blue cotton three-quarter-sleeve shirt (her fave outfit in the movie) is by Theory. And that lacy lingerie Katie sports? It's by the very sexy, very pricey La Perla.

Her Gal Pals

\mathcal{E}veryone needs girlfriends—to hang with, to gossip with, to help you scarf down a pint of Häagen-Dazs when Mr. Right doesn't return your calls. Katie has had her share of fellow leading ladies on screen, and (big surprise!) they all become her buds.

"With some people, you just click," she once explained. "Maybe it's because you're sharing the experience. Or maybe it's late at night and you've been working for, like, fourteen hours and you want to get a little crazy. . . ."

And that's where this trio comes in.

Michelle Williams

Date of birth: September 9, 1979

Hails from: Kalispell, Montana. But her folks moved to San Diego when she was nine.

Where she calls home now: A small Sherman Oaks apartment that she shares with a fellow actress and friend.

Family ties: Dad Larry is a commodities trader; mom Carla is a homemaker; sister is Paige.

School days: She attended Santa Fe Christian High School and graduated early. (Brains as well as beauty and blond ambition!)

Her first big break: At age fourteen, in the 1994 *Lassie* remake.

Career highlights: She appeared in two sci-fi flicks, *Timemaster* and *Species* (as a human-alien hybrid—her character evolves into Natasha Henstridge); the miniseries *Kangaroo Palace*; the film *A Thousand Acres* (she played Michelle Pfeiffer's daughter); *Halloween H2O* with Jamie Lee Curtis; *Dick* with Kirsten

Dunst; *Killer Joe* (off-Broadway play last summer in which she appeared nude).

On leaving her folks for Hollywood at age fifteen: "What can I say? I have this vicious independence streak," she told *InTheater Magazine*. "Right now, I'm amazed I'm still alive. I should either be a hooker or a crime statistic."

On what makes Jen tick: "She's not Mother Teresa. She does say the wrong thing and do the wrong thing, but she's straightforward about it. I do like her. It's fun being the bad girl, because you get a lot of interesting story lines thrown at you."

On working with Katie: "Wilmington is not a big city, so you need people around you to liven things up. Katie's a fun girl."

Lookin' for love?: "Not really," Michelle told *YM*. "I'm still figuring out who I am, so a steady boy isn't really what I want right now. Besides, I wouldn't know where to find the time!"

Web sites to watch: *www.geocities.com/Rain-Forest/Vines/2771/mwilliams.html*
http://homepages.lycos.com/MarLev/lycelebrity/MichWill.html

Meredith Lee Monroe

Date of birth: December 30 (year, "I'm not telling!")

Where she hails from: Houston, Texas; raised in Hinsdale, Illinois.

Family ties: She's an only child. Mom Judith is a client liason for Lucent Technologies; dad Jerol is a computer company manager.

School days: Attended Hinsdale Central High. Upon graduation, she decided against higher education and pursued a modeling career in New York City.

Her commercial career: A 1995 L'oréal television spot was her big break. She's since made more than thirty commercials and print ads including Huffy bikes, 7-Up, and Mattel toys (she's on the cover of the Compatability Game box).

The actor's life: She played Tracy Daiken on the 1997 ABC series *Dangerous Minds* (based on the Michelle Pfeiffer movie), which led to several other guest spots on television shows. She's set to star in the CBS movie *Beyond the Prairie: The True Story of Laura Ingalls Wilder* as "Half-

pint" herself, as well as the big-screen flick *Mary Jane's Last Dance* with Dominique Swain and Mia Kirshner in early 2000 (Meredith plays the lead role of Hadley).

On playing Andie McPhee on Dawson's Creek: "I had no idea if this was going to be a one-shot thing or turn into a regular role. I just crossed my fingers. But I kinda knew Andie had potential."

On working with Katie: "She was one of the first cast members I met, and though she teased me a lot, she really made me feel like one of the family."

Her main man: Nope, not Pacey. She's "romantically involved" with a twenty-eight-year-old New York City massage therapist named Steve.

Web watch: *www.celebritystars.com/meredith/meredith.html*
http://meredith.almilli.com/

Sarah Polley

Date of birth: January 8, 1979.
Hails from: Canada and now lives in Toronto.

Family ties: Dad Michael is an actor (he played Dr. Blair on *Road to Avonlea*); mom Diane was an actress and casting director, who died in 1988 of cancer when Sarah was eleven. She is the youngest of five children (two older brothers and two older sisters).

Career highlights: Started acting at age four in Disney's *One Magic Christmas*; also starred in *Hands of a Stranger* (made for TV); *The Big Town* (co-starring Tommy Lee Jones and Matt Dillon); *Ramona* (the television series, in which she played Ramona); *The Adventures of Baron Munchhausen* (with Robin Williams and Sting as well as her dad); *Lantern Hill*; *Road to Avonlea*; *Exotica*; *Joe's So Mean to Josephine*; Stradford stage production of *Alice Through the Looking Glass*; *The Life Before This* and *Guinivere* (both costar Stephen Rea); *eXistenZ; Go!* (with Katie); *Last Night; Jerry & Tom* (she has a cameo as a girl buying a car); *The Hanging Garden; The Planet of Junior Brown; The Sweet Hereafter* (the movie was nominated for two Academy Awards and won Cannes' Palm D'Or).

Upcoming projects: Scheduled for 2000, *The Weight of Water* with Sean Penn and Elizabeth Hurley.

Losing her religion: Sarah went through a "sort of Buddhist" phase in her life, but now maintains she "doesn't have faith in anything but my fellow human beings." She is, however, very veggie and into animal rights.

Go! for it: Sarah told the *Toronto Sun* about her role as checkout clerk Ronna Martin, "I always knew that I wasn't the right person to play that part—and I still believe that. I think someone else could have done it better." Katie's comment? "She's just Miss Modesty—she was great."

On shunning the star attitude: "Why is what you do any more important than someone driving a bus?" she asked John Clark of the *L.A. Times*. "I tend to think of this as so shallow and stupid."

A passion for politics: She's been an activist since she was a teen, campaigning for the Ontario Coalition Against Poverty, a group that protests cuts in welfare spending. In 1995 she temporarily gave

up acting to commit herself to her activism. At one demonstration things got a little out of hand, and a policeman knocked out a couple of her teeth!

Her main man: Kirk, a boyfriend of several years, who is a screenwriter. Sarah described their relationship as "very intense."

Web site to watch: http://cs.wilpaterson.edu/~led/Polley/Polley.htm

Katie's Style File

"My look is a little bit of everything."
—KATIE HOLMES

\mathcal{F}or the fashion 411 on Joey, you need only look to one man: the show's costume designer, Alonzo Wilson. Alonzo (who incidentally was born and raised in Wilmington, North Carolina) shops for the stars at Banana Republic, The Limited, Wet Seal, The Gap, Abercrombie and Fitch, and J. Crew. "I like to keep the clothes very normal for kids," he told *Elle* magazine. "More of a mall thing." In fact, in 1998 the gang even modeled for a J. Crew catalog, sporting tee shirts, polos, windbreakers, and rollneck sweaters. (James and Katie

are a couple of cuties in matching his and hers.)

For the 1999–2000 *Dawson's Creek* season, American Eagle Outfitters will become the show's "Official Clothing Provider." So look for cool new looks with a slightly more "outdoorsy" feel.

According to the clothing company, Alonzo was searching for ensembles that look and feel real, and that both cast and audience would find appealing and affordable. "I look for clothes that are easily accessible to teenagers," he said in a recent press release. "That way, if a viewer sees one of our characters and relates to them as a personality, then they can relate to the clothes as well and get those sorts of clothes. The idea is to make the character separate, but make them cool and identifiable to different sectors of our audience. So if a viewer sees Joey and likes her, she can easily find the same kind of tank tops and jeans she wears."

At the beginning of the season, Alonzo spends about eight hours a day shopping (talk about your dream job!), then putting the clothes in each of the characters'

"closets" in the wardrobe room. He buys two or three of each piece just in case they get wet, dirty, or wrecked during shooting (food fights among cast members can do that, you know!). After a while, he's built up a whole wardrobe for each star—and most of the outfits mix and match beautifully. Specific scripts of course may require something a little special—like the evening gown Joey donned for her beauty pageant. In that case, it's back to the racks once again. . . .

Joey's look: Chinos and white jeans, tiny tanks (they look innocent, but pack some serious sex appeal), sneakers, sandals, slouchy sweaters, baggy shorts. And let's not forget her S.S. Icehouse waitress attire. (Katie can even make a kitchen apron look good!)

Katie's look: Cooler and a little more sophisticated than Joey's. Some tailored suits and strappy sandals (when she knows cameras will be watching); jeans and leather jackets; beaded evening gowns for nights on the town. She's a

girl who appreciates the little details: cute pendants on illusion cords; sexy mules or slingbacks; a purse that perfectly matches her Audrey Hepburn sheath; texturized fabrics, sheer tops over tanks, and toes polished in pewter.

Her Beauty Booty

Katie's near-perfect peaches-and-cream complexion needs little makeup to look glowing (some girls have all the luck!). But there is a key to Katie's colors—soft, muted, well-blended neutrals and naturals. Here's how to create her look on yourself!

Foundation: Dot on a little under-eye concealer. Make sure it matches your own coloring—too white will be noticeable, too dark will make you look tired. Apply a light, oil-free foundation, blending well with fingertips. Dust (with a big brush or powder puff) with translucent powder.

Eyes: Stick with soft pastel shades for

your shadows—pink, lilac, beige—and sweep the color from lid to crease. Apply two coats of mascara (brush with a lash comb to avoid clumping). For an evening look, you can add more shimmer with frostier hues. Katie likes silvery shadows (MAC Twilight is a fave) that make her hazel eyes twinkle. Finally, sweep a smoky shadow underneath lower lashes to add drama. (Katie used a dark kohl liner when she played the more radical Rachel in *Disturbing Behavior*.)

Brows: Not too tweezed, please. You'll note that Katie never overdoes it. Just a neat arch and stray strands plucked from underneath. You can darken if you like with a soft-brown pencil or powder—but blend well.

Cheeks: Sweet and innocent—Katie always looks like she's blushing naturally (and she often is!). A soft pink-brown shade, applied just to the apples of the cheeks, adds warmth without looking overdone.

Lips: Sure, Joey told Jen her lipstick color

was "Wicked Red." But you won't ever catch the *actress* in such a garish hue! Instead, she opts for nudes, mochas, and sheer berry shades—just a hint of color and gloss to make her mouth look luscious. She also loves fruity, flavored lip glosses (which are, of course, very kissable).

Hair: Straight, shiny, shoulder-length, and parted down the middle: That's how you'll almost always see Katie's crowning glory. She deep conditions once a week and applies Kiehl's Creme with Silk Groom. Stylists, however, might apply some mousse at the roots to give her hair more volume or a shine-enhancing serum to make it sleek. If your hair has a bit more wave, you can blow it stick-straight using a big round brush. The color—if you get up close—is more chestnut than a deep, espresso brown. Katie has some natural red and blond highlights (hanging out on the dock in the sun filming *Creek* helps!). For evenings on the town, she's been known to crimp her locks and

wear them in a slightly tousled up-sweep with a few loose strands framing her face.

Katie on Camera

"She's a total pleasure to work with," gushes Robert Whitman, the New York City celebrity photographer who shot Katie for the cover of *YM* twice (once solo, once with the whole cast). "She's just adorable, very sweet, very obliging—zero attitude which is a joy and a rarity in this business."

When Katie posed, Robert said it was clear she was comfortable in front of the lens. "You can tell if someone has modeling experience because they're not afraid to move," he adds. "Katie is a natural. She would do anything—hang upside down if you asked her! She tried on every outfit and she was a real trooper. Believe me, it can get very tiring very fast, standing under hot lights a whole day. But she wanted to make it easy on everyone.

KATIE HOLMES

And her smile? It can light up a room. I think she has a long and successful future ahead of her."

Shop Till You Drop

To copy Katie's couture . . .

- J. Crew: 1-800-851-3189 or *www.jcrew.com*
- Abercrombie & Fitch: 1-800-432-0888 or *www.abercrombie.com*
- American Eagle Outfitters: *www.ae.com* to find the stores nearest you

10 Things You May Not Know About Katie Holmes

1. **She's a ham.** "Katie would get up and do fifteen karaoke songs on stage—she gets so fired up," her *Teaching Mrs. Tingle* costar, Marisa Coughlan, told *Seventeen*. "She has all this energy, and she's really, like, jumpy."

2. **She's no prima donna.** "She's so humble, you'd never know that she was Katie Holmes," adds Marisa.

3. **Sexual innuendo makes her squirm.** "Don't say penis around Katie,"

teased *Tingle* costar Barry Watson in *Seventeen*. "She gets really embarrassed."

"All the boys I work with give me a hard time," Katie admitted. "They like to embarrass me. They come up with these jokes and they know I don't get it."

4. **She got to play with Miss Piggy.** She had a walk-on role (as Joey) in *Muppets from Space*.

5. **She has one of the biggest hearts in Hollywood.** She volunteered at the Bullseye Booth at last spring's Elizabeth Glaser Pediatric AIDS Foundation fundraising carnival. Kids flocked to her and she didn't mind one bit—she signed autographs, handed out hugs, and posed for pics, including one with a nineteen-year-old HIV-positive patient. "This was one of my first charity events," she told *Teen People*. "And I want to do a lot more."

6. **She's always punctual.** It goes back to the days when her folks insisted she keep a curfew. "I always dated nice

boys and got home early," Katie told *Seventeen*.

7. **Makeouts (on-screen) make her nervous.** "I have to remind myself that it's acting," she says. "Otherwise, my palms start to sweat."

8. **She's still big on Barbie.** "I still have about twenty of them," she confessed to *Seventeen*. "Plus a Corvette, workout center, waterslide park . . ."

9. **She has a flare for interior design.** Her newly purchased condo in Wilmington looks "pretty cool," she says—and a lot like an ad for Pottery Barn right now.

10. **She has serious road rage.** "Traffic, especially in LA, is a pet peeve," she admitted recently. "And I drive way too fast." That's something that no doubt she's going to work on—the last thing Katie would want is a serious car accident!

Fast Foward: Katie's Future

"I hope interviewers are not expecting me to come out with some great philosophy of life."
—KATIE HOLMES

\mathcal{N}ow in its third season, *Dawson's Creek* shows no signs of losing any steam with its audience. And the plots continue to thicken.

"I'm really happy with where Joey is headed," Katie told *USA Today*. "I was really sick of playing the depressed, 'Poor me, I want him' role. I think we have to give the audience what it wants."

And what might that be? "Umm, you know . . ." she squirmed on a recent talk show. "They want Dawson and Joey to do it." She'll give no hints as to whether that

will happen or not, although they've come pretty close in the past. "I'm a hopeless romantic," she told the *Calgary Herald*. "I think I'd be upset if it they didn't eventually get together in that way. I just hope my mom isn't watching that night!"

But Joey, she theorizes, will have a lot more on her plate next season than just dealing with her feelings for Dawson. "I'm proud of Joey," she has commented. "Her goal in life was Dawson, but now she's growing into herself, becoming a woman."

And the same can be said for Katie. "There's so much growing I want to do as a person," she told *Life*. College is still a definite goal—all of her siblings are college grads. She's deferred admission twice to Columbia University ("I hope they don't get mad!") but swears she'll one day get her diploma.

"I hope I'm not too old by then," she once teased. "The other freshmen will make fun of me. I'll be this old lady and they'll ask me to buy them beers."

In the meantime, she keeps up with her reading. "I don't want to get to college

and be like, 'Homer who? Who's this Thoreau?' " she joked with *TV Guide*. "College is not something I look upon lightly. I want to give it my entire attention and that's not possible right now."

The past three years have been a wild ride for Katie and the *Creek* company, and once in a while, she likes to just sit back and evaluate what's happened to her. "It's so strange," she told the *Memphis Commercial Appeal*. "All the four of us did was audition for, like, twenty minutes and everything changed and all this stuff was thrown at us at once."

Any regrets? "Not yet," she answers without hesitation—although Katie *is* well aware of the tendency of Hollywood to exploit its youth. A photographer recently asked her to pose in a wet tank top for a magazine cover—and Katie was wise to his request.

"I just stayed in the water—you couldn't see anything," she said. "It's funny how people try to sweet-talk you in this business and say things and you know they're lying. I'm like, 'No, I can't wear that. I'm

sorry, I'm from Ohio, and I don't want people to see me in that.' "

Her next project is a big one: *Wonder Boys,* starring Michael Douglas and based on the novel by Michael Chabon. The Paramount Pictures film is being directed by Curtis Hanson. Michael plays a writer and professor who is behind deadline for turning in his second novel. Katie is Hannah Green, one of his students with a major crush on him. "I'm a freshman and he's having this midlife crisis . . . ," Katie told the *Calgary Sun*. Hannah hooks up with her teacher (hmmm, sounds like a Pacey/Tamara thing, don't ya think?) and gets her hands on the unfinished manuscript. According to the *Hollywood Reporter*, her character is "the catalyst that causes him to have an epiphany on life." The movie also costars Robert Downey, Jr. as Michael's book editor and Tobey Maguire as a fellow student.

"I look forward to more challenging older roles," she told the *New York Daily News*. "It's an incredible time to be an actor in Hollywood." In a recent Q & A with Molly Ringwald in *Interview Maga-*

zine, she confessed she'd even love to try her hand at Shakespeare! "A sweeping, romantic period piece would be great," she said.

So Katie is now playing in the big leagues—but she's pretty practical and levelheaded about it. "Right now, I just want to be smart about it," she told the *Austin-American Statesman*. "I've been given unbelievable opportunities, and what I hope to do is take advantage of them, and really grow up and mature into a strong woman, a strong actress."

Success, she once reflected, is not about making money. "It's about getting an education and being happy. I don't have this big ego about it. I don't think there's any mark I can make."

Despite her humility, we all know better: There's no underestimating just how far Katie Holmes will go. "I'm still having fun playing a teenager," she told the *Austin Statesman*. "I'm still having fun being that little kid and embracing my youth. But parts of me do want to be that twenty-five-year-old who is in complete control and ready to conquer the world."

KATIE HOLMES
What's in Katie's Stars?

Katie is a Sagittarius—one of the strongest and most driven signs in the Zodiac. So it's no wonder she's come so far so fast—Sag ladies never take no for an answer!

There are others who share her DOB (December 18): Steven Spielberg (no wonder Dawson digs her!); baseball legend Ty Cobb; Rolling Stone legend Keith Richards; and movie bombshell Betty Grable. So obviously Katie's in great company!

Best Traits: Dedicated, Driven, Determined

Here are a Sag's strong points: Sags are hopelessly devoted when it comes to people and projects. If Katie's your gal pal, lucky you: Her stars indicate she's a friend true and blue (just ask her kindergarten compadre, whom she still calls daily!). And if you're dating her, you never have to worry about infidelity—when a Sag says she loves you, it's forever (which explains why she and Josh are still tight). The symbol for this sign is the archer—which

is appropriate, since Sags always keep their eyes on their target. Once something or someone is in their range, they never lose sight of what's important. . . .

Worst Traits: Unyielding, Unreasonable, Perfectionist

And here are a Sag's weaknesses: Sure, it's great to stick to your guns. But Sags *can* be a little stubborn, refusing to give up on something when they should. They cling to relationships that should have been ended long ago, and hold on tight to bad habits. They also tend to stress themselves out with lofty goals and unreasonable expectations: Hey, Katie, try and remember that no one can be two places at once! Accuse a Sag of being a workaholic and she'll bristle: She's not too busy, it's just that everybody else is too lazy!

Fast Foward: What the Stars Hold for Her Future

Health: Katie may be feeling a little overwhelmed and overextended at the start

of the new millennium. The stars indicate she may need to calm down, to enjoy her newfound stardom in stride rather than worrying about where she's headed. Some good astral advice: Take time to stop and smell the roses! There's a tendency for all Sags to spread themselves too thin this year. Katie also should consider a retreat somewhere quiet and peaceful—maybe a spa weekend getaway or a tropical vacation on a secluded island.

Romance: The stars say there's romance in the air with not just one but *several* suitors (hey, maybe she won't be alone in tropical paradise!). But with so many men and so little time, Katie may not be able to make up her mind. She has a long list of required qualities for the partner she needs to make her happy, and she won't settle for second best. The problem seems to lie in Katie's past: She's been disappointed before and learning to love again is never easy. The good news is that Jupiter (the planet of richness and her ruler) enters Katie's

love sector in the year 2000, bringing some hope for a future happy ending. A hint for her heart: It's good to be choosey, but no guy is absolutely perfect. Take a chance

Money: Dinero is definitely in her chart this year! Big projects—some of the biggest of her life—loom around the corner, as well as a number of other profitable business opportunities (can you say "commercial endorsements"?). The stars also seem to indicate that the very independent Ms. Holmes may be contemplating forming a little biz of her own—maybe her very own film company. How's this for a name: Kate the Great Productions!

Personal growth: Pluto, the planet of transformation and rebirth, promises that Katie is in for a period of some major soul searching. What will she discover? That she's capable of incredible inner strength and courage. No more shy and sheltered girl from Toledo! She'll be

poised, polished, and ready to play in the big leagues (as if she isn't doing that already!).

BOY NEXT DOOR

The James Van Der Beek Story

by Alex Tresniowski

Riding high on the huge success of his film *Varsity Blues* and with his hit show *Dawson's Creek* about to enter its third season, James Van Der Beek is poised to become one of the hottest commodities in Hollywood.

Just like the sensitive, soulful, and oh-so-sexy Dawson, James grew up in a small New England town, where he dreamed of big-time success and excelled at everything he tried: sports, academics, music, and especially drama. In *Boy Next Door*, you'll find out how he discovered acting and the hits and misses of his early career. And, of course, you'll get all the essentials—his passions and turn-offs, his hopes and aspirations, his dates and loves.

Published by Ballantine Books.
Available at bookstores everywhere.

TRUE BRIT

The Story of Singing Sensation

Britney Spears

by Beth Peters

Britney Spears is putting girls back on the map in the pop music world. With . . . *Baby One More Time*, her first album, Britney shot straight to the top of the charts in just the first week of the album's release.

But Britney didn't come out of nowhere. She broke into the biz at the tender age of eight, and it wasn't long before she made her mark. *True Brit* gives you all the backstage info, from her first audition for *The New Mickey Mouse Club* to her exciting decision to go solo. You'll find out what it was like for Britney to work with the boys of 'N Sync, the rumors of romance, and her dazzling life beyond the stage.

Published by Ballantine Books.
Available at bookstores everywhere.